D0553576

FATHER'S

on

the

Phone

WITH

the

Flies

THE GERMAN LIST

HERTA MÜLLER

FATHER'S
on
the
Phone
WITH
the
Flies

A Selection

TRANSLATED BY
THOMAS COOPER

Seagull
BOOKS

LONDON NEW YORK CALCUTTA

ST. JOHN THE BAPTIST PARISH LIBRARY
2920 NEW HIGHWAY 51
LAPLACE, LOUISIANA 70068

This publication was supported by a grant from
the Goethe-Institut India

Seagull Books, 2018

Originally published as Herta Müller, *Vater telefoniert mit den
Fliegen* © Carl Hanser Verlag München, 2012

First published in English translation by Seagull Books, 2018

English translation © Thomas Cooper, 2017

ISBN 978 0 8574 2 472 3

British Library Cataloguing-in-Publication Data
A catalogue record for this book is available
from the British Library.

Typeset and designed by Sunandini Banerjee,
Seagull Books, Calcutta, India
Printed and bound by Hyam Enterprises, Calcutta, India

News that Was Clear as a Knife

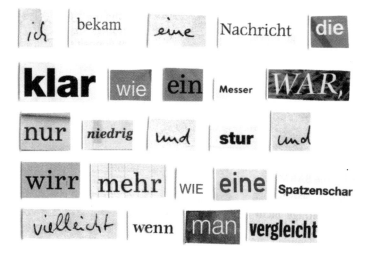

ich bekam eine Nachricht die klar wie ein Messer *WAR,* nur *niedrig* und **stur** und wirr mehr WIE eine Spatzenschar vielleicht wenn man vergleicht

I got news
that was clear
as a knife
only low and stubborn
and confused
more like
a flock of sparrows
perhaps
if one compares

ein Beispiel (für
anarchisch ist eventuell die
Bahnhofsuhr ein Hasenfell
statt ZIFFERBLATT – egal, was sie
noch vor sich
hat es riecht nach
Chlor und Klingeldraht.

an example of
anarchistic is perhaps
the train-station clock
a rabbit pelt instead
of clock face — no matter what
is in store for it
it stinks
of chlorine
and bell wire

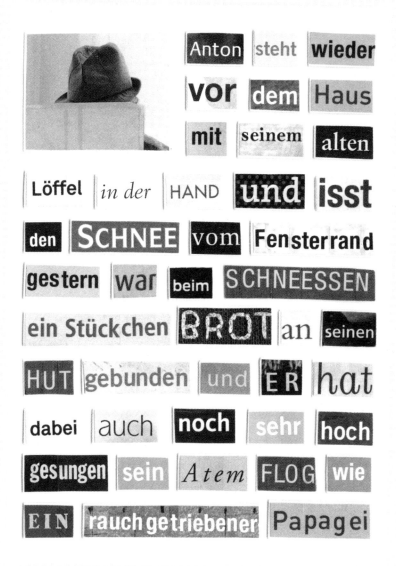

Anton steht wieder vor dem Haus mit seinem alten Löffel in der HAND und isst den SCHNEE vom Fensterrand gestern war beim SCHNEESSEN ein Stückchen BROT an seinen HUT gebunden und ER hat dabei auch noch sehr hoch gesungen sein Atem FLOG wie EIN rauchgetriebener Papagei

Anton stands again
in front of the house
his old
spoon in hand
eating
the snow from the windowsill
yesterday as he snowate
a little piece of bread was tied
to his hat and he sang
very high
his breath flew like
a parrot driven by smoke

Weit im WIND laufen
DIE orte vorbei
– verlorene Mäntel
GEFÜTTERT MIT Heu

far in the wind
the places run by
— a lost coat
lined with hay

1x am **Zug** vor **20** JAHREN

**Tür auf.
Einsteigen.
Losfahren.**

Bloß keinen **ABSCHIED**

SIE **nickten** sich **2x** ZU

mit BLICKEN BEI denen

MAN **nicht** sehen durfte

dass SIE sich KENNEN.

1 x on the train 20 YEARS ago
Open door.
All aboard.
Depart.
Just no farewell
they nodded 2 x
glances that didn't
let anyone see
they knew each other.

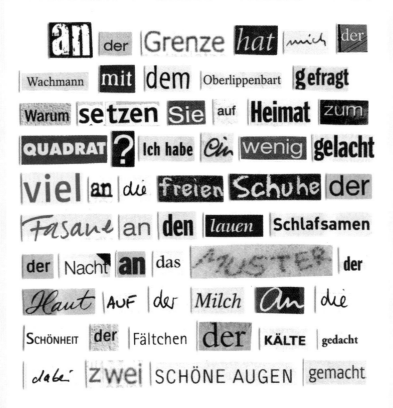

an der Grenze *hat* mich der Wachmann **mit** dem Oberlippenbart **gefragt** Warum **setzen** Sie auf **Heimat** zum **QUADRAT ?** Ich habe *ein* wenig **gelacht** viel an die freien Schuhe der Fasane an **den** lauen Schlafsamen der Nacht **an** das MUSTER der Haut AUF der Milch an die SCHÖNHEIT der Fältchen der KÄLTE gedacht dabei zwei SCHÖNE AUGEN gemacht

at the border the guard
with the moustache asked
why do you set out homeland
squared? I laughed a bit
thought a great deal about
the free shoes of the pheasant
the mild
sleepfulnesses of night
the pattern of the skin on the milk
the beauty of the wrinkles of cold
and all the while made two pretty eyes

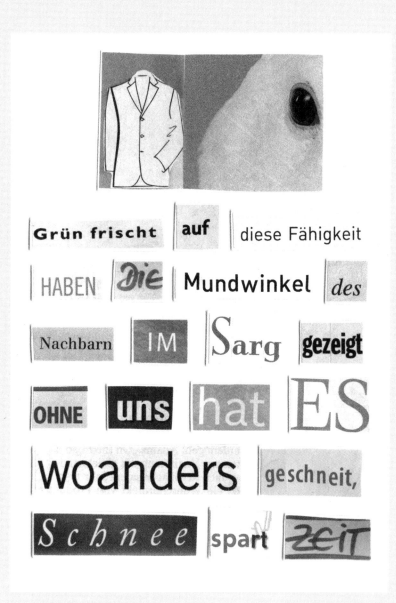

Grün frisch *auf* diese Fähigkeit HABEN *Die* Mundwinkel *des* Nachbarn IM Sarg **gezeigt** OHNE uns hat ES woanders geschneit, Schnee spart ZEIT

Green refreshes
the corners of
the neighbour's mouth
showed
this ability
in the casket
without us it
snowed
elsewhere
snow saves time

GESTERN sagte Herr Straub

HOLZ MACHT STOLZ und dann Was immer passiert, Hauptsache KARIERT

Ich dachte, ER nimmt sich

DIE EINFACHHEIT DIE

es eilig hat, aus dem Silbersack

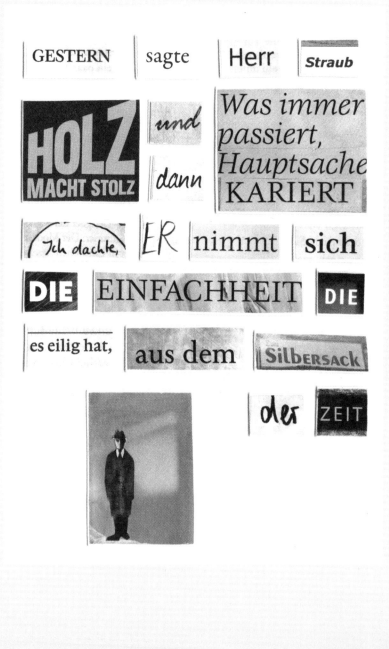

der ZEIT

Yesterday Mr Straub said
wood
is good
and
then
whatever the fad
the main thing is plaid
I thought he's taking the
the simplicity that is in a rush
out of the silver sack
of time

BEIM GRAUEN Eisen turm

ZOG DIE rote KUH

DEN weißen Umhang AN

VON einem Gänse schwarm

ging HEIM durchs grüne

TAL da man SIE im

weißen STALL nicht sah

by the grey iron tower
the red cow put
the white cloak on
from a swarm of geese
went home through the green
valley because no one saw
her in the white stall

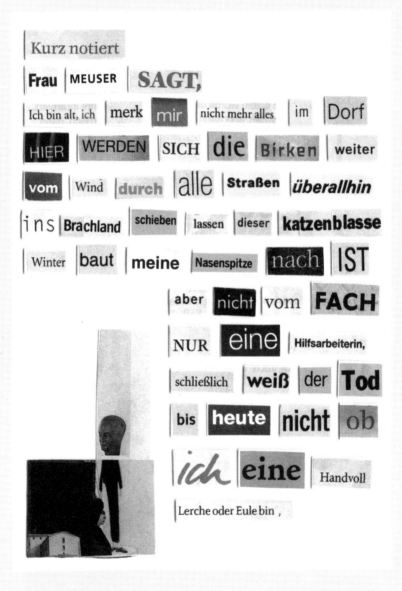

Kurz notiert

Frau MEUSER SAGT,

Ich bin alt, ich merk mir nicht mehr alles im Dorf

HIER WERDEN SICH die Birken weiter

vom Wind durch alle Straßen überallhin

ins Brachland schieben lassen dieser katzenblasse

Winter baut meine Nasenspitze nach IST

aber nicht vom FACH

NUR eine Hilfsarbeiterin,

schließlich weiß der Tod

bis heute nicht ob

ich eine Handvoll

Lerche oder Eule bin ,

briefly noted
Mrs Meuser said,
I am old, I no longer notice everything in the village
here the birches let themselves be pushed by the
wind
every which way through all the streets
this catspale winter copies the tip of my nose
but is not a pro
just an assistant
in the end
death doesn't know
to this day
whether I am
a handful
of larks or owls

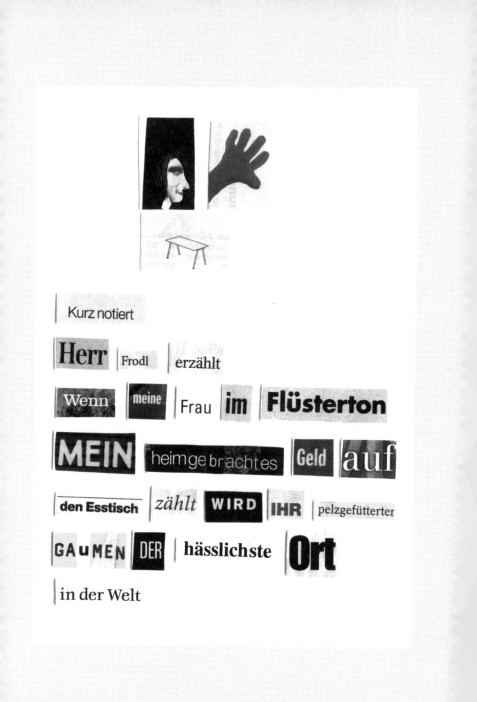

Kurz notiert

Herr Frodl erzählt

Wenn meine Frau **im Flüsterton**

MEIN heimgebrachtes Geld auf

den Esstisch *zählt* **WIRD** **IHR** pelzgefütterter

GAuMEN DER hässlichste **Ort**

in der Welt

briefly noted
Mr Frodl says
when my wife
counts the money
I bring home
under her breath
on the dinner table
the fur-lined roof
of her mouth becomes
the ugliest place
on earth

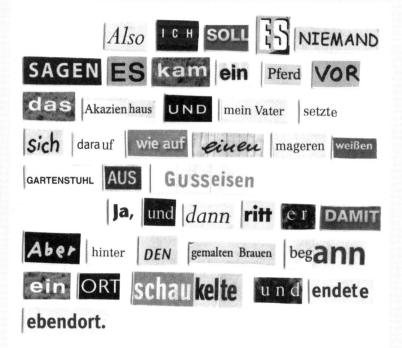

Also ICH SOLL ES NIEMAND SAGEN ES kam ein Pferd VOR das Akazienhaus UND mein Vater setzte sich darauf wie auf einen mageren weißen GARTENSTUHL AUS Gusseisen Ja, und dann ritt er DAMIT Aber hinter DEN gemalten Brauen begann ein ORT schaukelte und endete ebendort.

so I should not tell
anyone a horse came along
in front of the acacia house
and my father sat on it
like a thin white garden chair
out of cast iron
yes, and then he rode with it
but behind the painted brows
a place began seesawed and ended
in that very spot

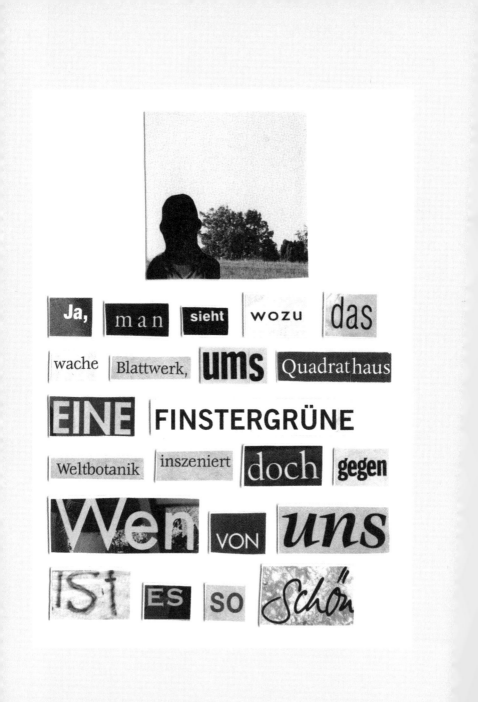

Ja, man sieht wozu das wache Blattwerk, ums Quadrathaus EINE FINSTERGRÜNE Weltbotanik inszeniert doch gegen Wen VON uns IST ES SO Schön

yes, one sees why the
awake
foliage around the square house
staged
a glowering green
world of botany
but against
which of us
is it so beautiful

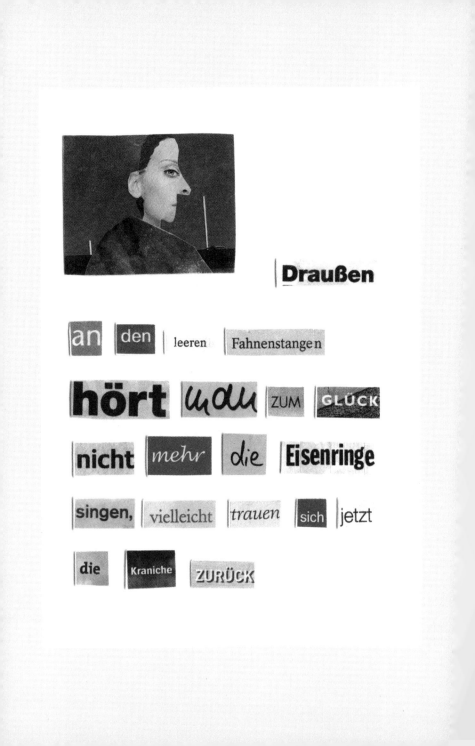

Draußen

an den leeren Fahnenstangen

hört man zum GLÜCK

nicht mehr die Eisenringe

singen, vielleicht trauen sich jetzt

die Kraniche ZURÜCK

Outside
by the empty flagpoles
fortunately one no longer hears
the iron rings singing
perhaps the cranes
now dare
to return

Mutter sagt am Telefon der Holunder
blüht sich müd zwei Sommer
hast du schon verpasst wenn
der Nachbar NACH dir fragt
LÜG ich dass DU Heimweh
hast die Pendeluhr die du
SO magst hab ICH verkauft
SIE tickt SO laut dass

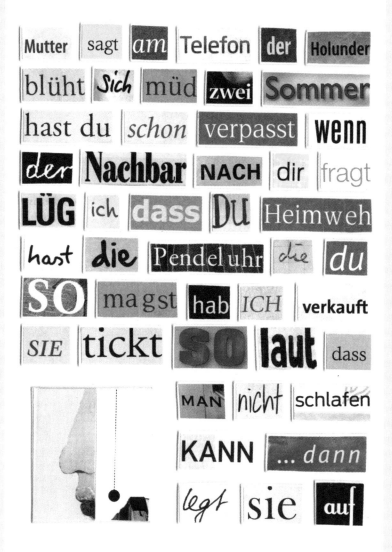

MAN nicht schlafen
KANN ... dann
legt sie auf

Mother says on the phone
the elderflower is in bloom
sleepy two summers
already gone by
when next door they ask
about you
I lie
say you're homesick
I have sold the pendulum clock
that you liked so much
it ticked so loud
I can't sleep . . . then
she hangs up

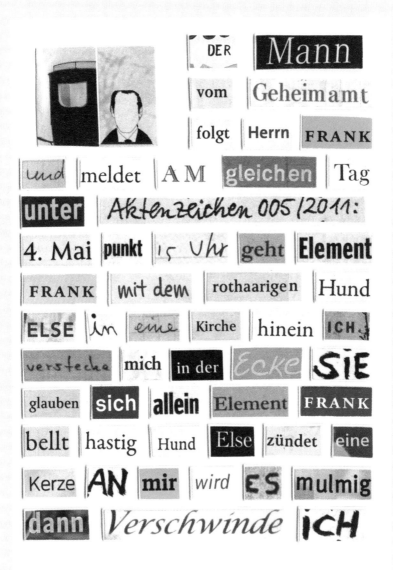

DER Mann vom Geheimamt folgt Herrn FRANK und meldet AM gleichen Tag unter Aktenzeichen 005/2011: 4. Mai punkt 15 Uhr geht Element FRANK mit dem rothaarigen Hund ELSE in eine Kirche hinein ICH verstecke mich in der Ecke SIE glauben sich allein Element FRANK bellt hastig Hund Else zündet eine Kerze AN mir wird ES mulmig dann Verschwinde ICH

the man from
the secret service
followed Mr Frank
and filed the report the very same day
under file number 005/2011:
4 May exactly 15 o'clock element
Frank goes with the red-haired dog Else
into a church I
hide in the corner
they think they are alone
element Frank barks hurriedly
dog Else lights a candle
I feel queasy
and then clear out

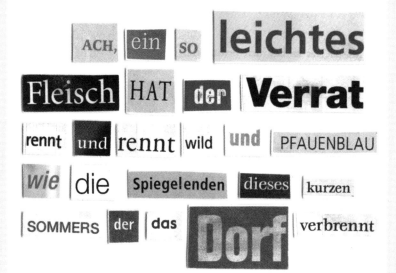

ACH, ein so leichtes Fleisch HAT der Verrat rennt und rennt wild und PFAUENBLAU wie die Spiegelenden dieses kurzen SOMMERS der das Dorf verbrennt

ah betrayal
has such light flesh
runs and runs wild and peacock blue
like the mirror ends of this short
summer which burns the village
to ash

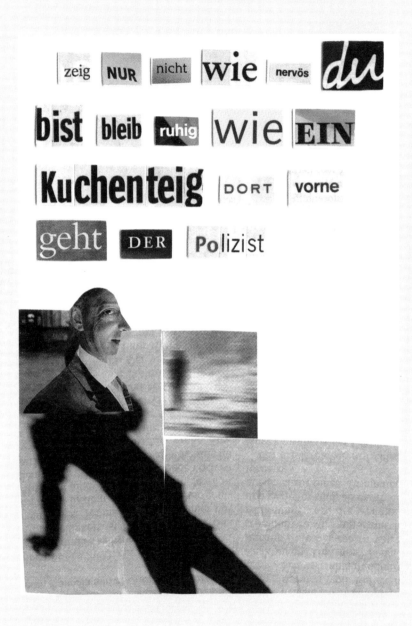

don't show
no matter
what how nervous
you are
stay calm
like cake batter
there's a policeman
out front

DER Notar trug
DAS weißeste
Hemd aus
Zuckerwatte und
WIR sangen drei Mal hoch soll
ER Leben weil ER Geburtstag
hatte doch das Hemd- Material
blieb BEI den langen Umarmungen
AN den Händen kleben DA
WAR DER Notar oben nackt
und wir leckten bemüht dass
ERS nicht sieht einer
dem anderen die Finger ab

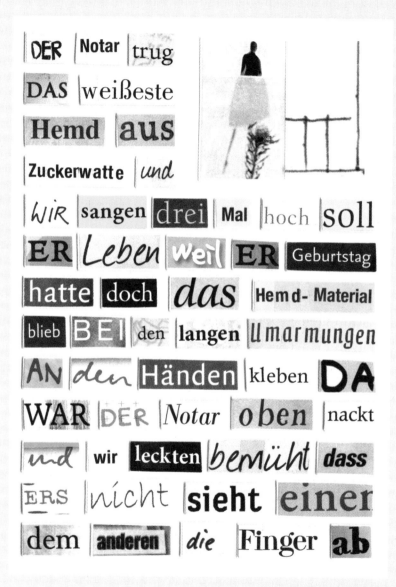

the notary wore
the whitest
shirt made out of
cotton candy and
we sang for he's the jolly good fellow
three times because it was his birthday
but the material of the shirt stayed
after the long embraces
stuck to your hands
the notary was naked up top
and we licked
amused that he didn't see it
one finger after the other

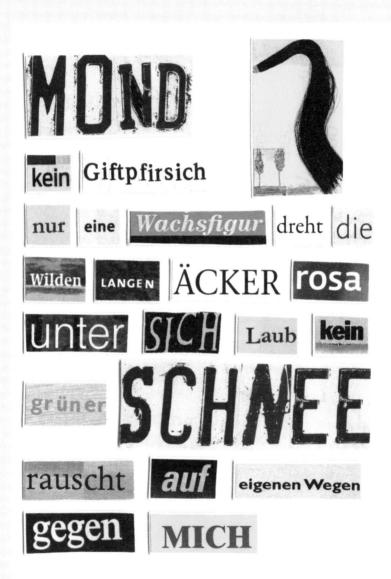

MOND

kein Giftpfirsich

nur eine *Wachsfigur* dreht die

Wilden LANGEN ÄCKER rosa

unter SICH Laub kein

grüner SCHNEE

rauscht *auf* eigenen Wegen

gegen MICH

moon
no poison peach
only a wax figure turns the
wild long fields rose
under it foliage no
green snow
rustles on its own way
against me

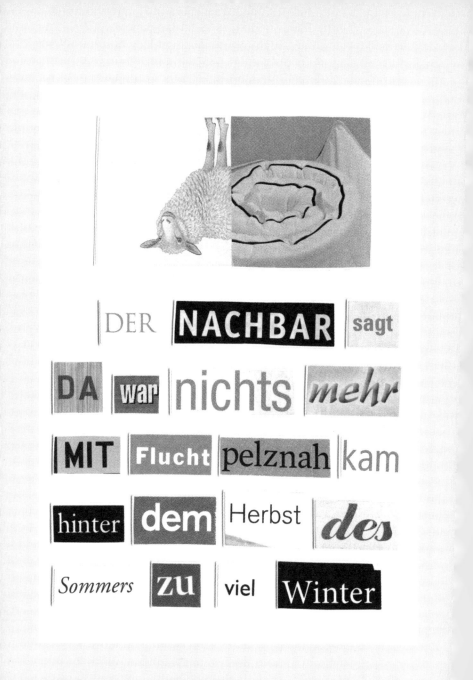

DER **NACHBAR** sagt
DA war nichts *mehr*
MIT Flucht pelznah kam
hinter dem Herbst *des*
Sommers zu viel Winter

the neighbour said
there was nothing left
with flight came skinclose
after the autumn
of summer
too much winter

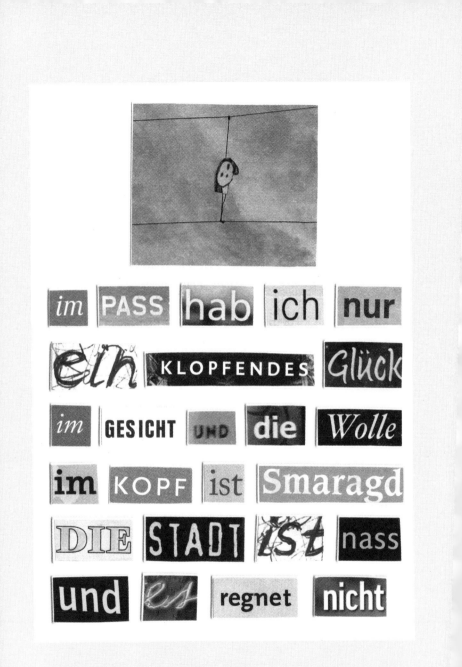

im PASS hab ich nur
eih KLOPFENDES Glück
im GESICHT UND die Wolle
im KOPF ist Smaragd
DIE STADT ist nass
und es regnet nicht

In my passport I have only
a thumping contentment
in my face and the wool
in my head is emerald
the city is wet and
it's not raining

wieder WAR Vater so MÜD dass er IM GEHEN schlief und wir folgten IHM OHNE ein Wort ich trug seinen LIEBLINGSHUT in der Hand Mutter NUR IHRE

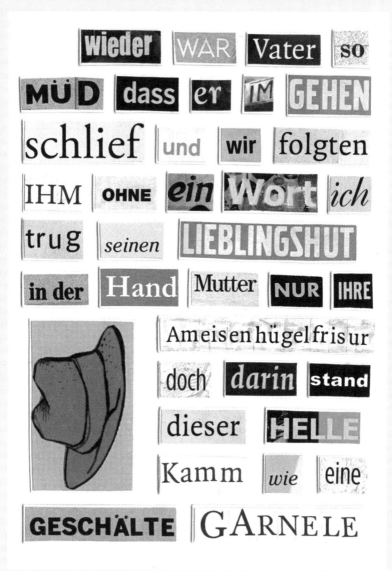

Ameisenhügelfrisur doch darin stand dieser HELLE Kamm wie eine GESCHÄLTE GARNELE

Father again was so
tired that he slept
while walking and we
followed him without a word I
wore his favourite hat
in my hand mother only her
anthill hairdo
but in it stood
this bright
comb like a
peeled prawn

Es gibt Tage, schwer wie Erde leer
wie Wasser manche Leute saufen
sich den Kapitän schön andere ziehen
auf dem Boulevard in der Innenstadt
den HUT IM QUADRAT ICH stelle
manche Tage meinen Wecker AUF
die Küchenwaage

wir WOHNEN hier im zehnten Stock – nur
gehört unser Wohnblock schon ab Schulterhöhe zur
himmlischen Monokultur sagt Zacherl DER Herr
Veterinär VOM Hippodrom ER sitzt SCHRÄG,
und richtet sich MIT DEM Teelöffel die Haare,
wenn ich ihn zu LANG im SPIEGEL seiner
Tasse reden LASSE obendrein zieht ER
ein Stück extrafeinen Draht aus seinem Jackett
Sehr zu empfehlen gegen die Nervosität
meint ER wirklich sehr

there are days, heavy like earth empty
like water some people booze down
the captain lovely others doff
hats squared on the boulevard
in the town centre
for the past few days
I've put my alarm clock
on the kitchen scales
we live here on the tenth floor — only
our apartment block belongs from shoulder height
to celestial monoculture says Zackerl the Mr
Veterinarian from the hippodrome he sits sloping
and rights his hair with the teaspoon
when I let him read too long in the mirror of his cup
just for good measure he pulls a piece
of extra-fine wire out of his jacket
highly recommended to treat nerves
he says really highly

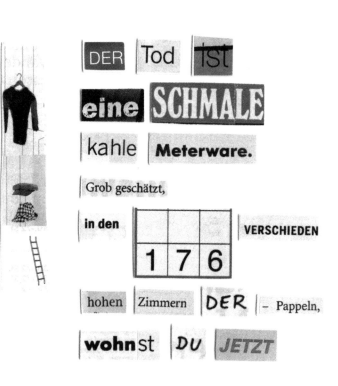

DER Tod ist eine SCHMALE kahle Meterware. Grob geschätzt, in den 1 7 6 VERSCHIEDEN hohen Zimmern DER – Pappeln, wohnst DU JETZT

death is
a small
bare material
sold by the yard
rough estimates
now you live
in the 176 rooms
of the
poplars
at varying heights

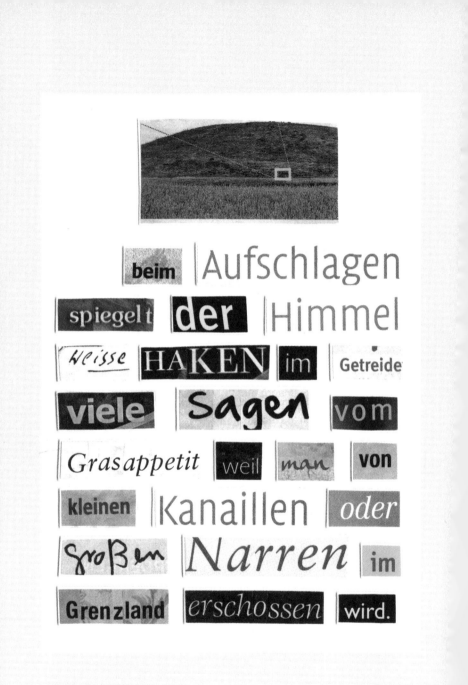

beim Aufschlagen

spiegelt der Himmel

Weisse HAKEN im Getreide

viele Sagen vom

Grasappetit weil man von

kleinen Kanaillen oder

großen Narren im

Grenzland erschossen wird.

when thrown open
the sky mirrors
white hooks in grain
many people say
from the appetite for grass
because in the borderland
one is shot
by small scoundrels or
big fools

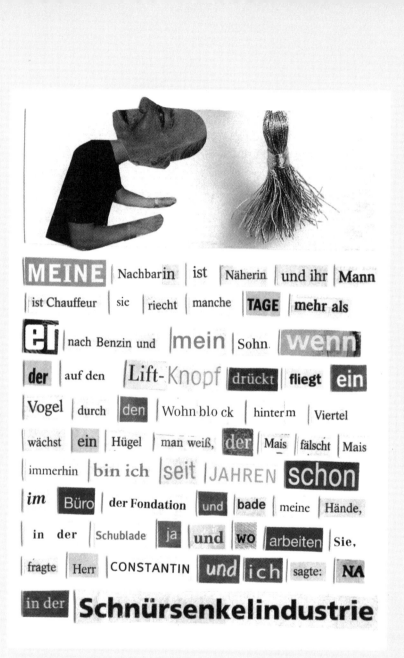

MEINE Nachbarin ist Näherin und ihr Mann ist Chauffeur sie riecht manche TAGE mehr als er nach Benzin und mein Sohn wenn der auf den Lift-Knopf drückt fliegt ein Vogel durch den Wohn blo ck hinter m Viertel wächst ein Hügel man weiß, der Mais fälscht Mais immerhin bin ich seit JAHREN schon im Büro der Fondation und bade meine Hände, in der Schublade ja und wo arbeiten Sie, fragte Herr CONSTANTIN und ich sagte: NA in der **Schnürsenkelindustrie**

my neighbour is a seamstress and her husband
a chauffeur for several days she has smelt
more than he like gasoline and my son when he
presses the elevator button a bird flies
through the apartment block behind the quarter
a hill is growing one knows that corn fakes corn
all the same I have been in the office of the foundation
for years and wash my hands in the drawer
yes and where do you work asked Mr Constantin
and I said: well in the shoelace industry

Ich fürchtete die Winterbirne und andere Früchte dies Klopfen, DAS AN DER Tür MIT dem Klang von Spielholz begann, und WIE EIN GANZER Staat aus Weißen AMEISEN den Hals hoch kroch weil IM Treppenhaus DER stille NARR der Würfelspieler war

I feared
the winterbulb
and other
fruits this
knocking which began
at the door with the sound
of playwood
and like an entire state
out of White ants
crept up the throat
because in the stairwell
the quiet fool was
the man throwing dice

DER Gerichtsmediziner hat grünliche Zeigefinger
und eine Stirn hoch wie ein Zimmer wenn er
behauptet wer stirbt dem frisst
ein Hase im Gesicht in einer Hinsicht
friert ER und ist weiß in der
anderen Hinsicht nicht und alles WAS
den Mais angeht ist sehr konkret WEIL er
ZUM Laub fressen und Ohren messen, im Haus
den Stuhl um wirft wenn ER DIE

GRÜNE
Schraube
UNTER M
Dorf
komplett
zur Seite
dreht

the forensic doctor has greenish index fingers
and a forehead high like a room when he
claims when someone dies a rabbit eats
in his face in one respect he freezes and is white
in the other respect not and everything that con-
cerns
corn is very concrete because he pushes the stool
over
in the house to eat leaves and measure ears
when he turns the
green
screw
under
the village
completely
aside

Vater **hat** seinen **kleinen** nichtgefallenen **Soldat** *der* **ER** war **AUF** dem **ARM** *- und* unser **Nachbar** fragt *wieso* TRÄGST **DU** *den* es *ist* doch unbequem; Vater **sagt** INNEN *sowieso* als AUCH AUSSERDEM

Father has
his small
soldier
not fallen
not liked
which was him
on his arm — and our
neighbour asks why
do you wear it
it's uncomfortable
how do you bear it; Father
says inside anyway and also
otherwise

dass MICH
die KLEINE
Heimat DIE
es je gab
am fünften ZEH mit der
großen Wolkenglatze und DER
Mütze eines STAATES UND
den Augen einer ZIEGE und
der Schnauze einer Ratte
FAMILIÄR leergefressen hatte,

That the small
homeland that
there ever was
on the fifth toe
with the big cloud pate
and the cap of a state
and the eyes
of a goat
and the nose of a rat
familiar
ate my plate
clean,

DER UMGEBRACHTE Freund darf
gratis IM NEST der Gräser
übernachten DIE Straßenkatze trägt
heiße MILCH im Bauch im SCHÄDEL
kaltes ungeheuer grünes Feuer
der WIND Kennt nicht DAS viele
STILLE Laub in das ER rennt
DIE Nacht auch NICHT das
hochgeschlossene Kleid DAS SIE
sich näht ES ist früher spät

The murdered friend can spend the night
in the nest of the grasses
free of charge the stray cat
carries hot milk in its belly in its skull
a cold monster warm fire
the wind doesn't know this
many quiet leaves in that it runs
the night doesn't know the high-necked dress
that it sews for itself it is
late earlier

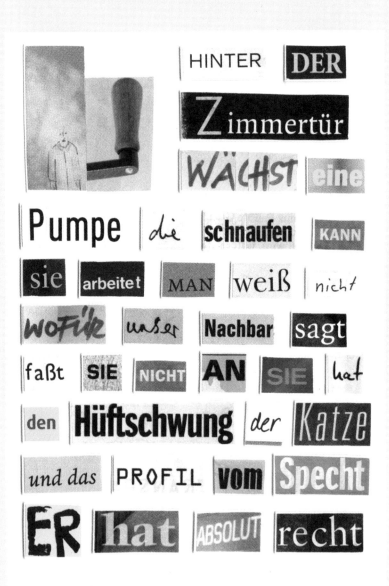

HINTER DER
Zimmertür
WÄCHST eine
Pumpe die schnaufen KANN
sie arbeitet MAN weiß nicht
wofür unser Nachbar sagt
faßt SIE NICHT AN SIE hat
den Hüftschwung der Katze
und das PROFIL vom Specht
ER hat ABSOLUT recht

behind the
door to the room
grows a pump
that can pant
it works no one knows why
our neighbour says
doesn't she get it she has
the hip swing of cats
and the profile
of a woodpecker
and he's absolutely
correct

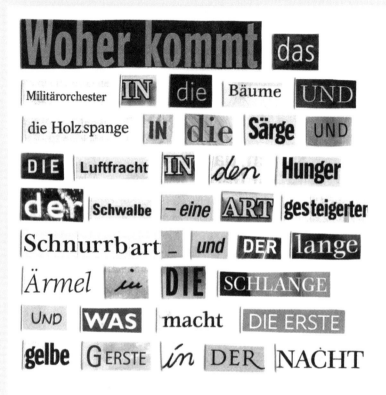

Woher kommt das Militärorchester IN die Bäume UND die Holzspange IN die Särge UND DIE Luftfracht IN den Hunger der Schwalbe – eine ART gesteigerter Schnurrbart _ und DER lange Ärmel in DIE SCHLANGE UND WAS macht DIE ERSTE gelbe Gerste in DER NACHT

where is the army orchestra
coming from in the trees
and the wooden buckles in the coffins
and air freight in the hunger
of the swallows — a kind of augmented
moustache — and the long
sleeves in the line
and what makes the first
yellow barley in the night

Vielleicht **springt** MAN aus Angst

mit der STARREN Nase voraus **in die**

Kleider des **Kuckucks** in die

SANDALEN des **Asphalts** der MOND

ziert seine HALSWIRBEL mit Ruß macht

sich AUF ins nächste Kaff und heiratet

das Kind im Mann das Milchlicht im

Totholz mancher zugigen *Veranda*

oder EIN **Zuckerbrot** und

kein Mensch weiß

ob ER ertrinkt

ODER verdorrt

perhaps one leaps out of fear
with a rigid nose ahead in the
clothing of the cuckoo in the
sandals of the asphalt the moon
decorates its cervical vertebra
with soot makes its way to the next
jerkwater town and marries
the child in man the milklight in the
deadwood of some draughty veranda
or a sweetmeat and
no knows whether
he is drowning
or drying up

Die Lüge ist ein Klettertier würde MIR immer noch mit Lachtränen die Geige spielen Doch wahr ist auch: auf dem Dach wächst ein Klavier

the lie is a climbing animal
would still play violin for me
with tears of laughter
but it's also true:
on the roof
a piano is growing

Snow is a Playless Case

Bei uns wird **mit**

ROTEN **Händen** Schach gespielt die FIGUREN sind **Hundepfoten** einmal plädierte **ein** Neuankömmling **für** DIE Abschaffung DER KÖNIGIN bis ihn einer fragte: hast **Du** je **ein** weißes Reh in braunem Schnee GESEHEN DA lächelte DER NEUE trüb UND wollte **gehen** und BLIEB

here
we play chess
with red hands
the chess pieces
are dogs' paws
once a newcomer pleaded
for the abolition of
the queen until someone asked him
have you ever seen a white doe
in brown snow
the newcomer laughed drearily
wanted to go
and stayed

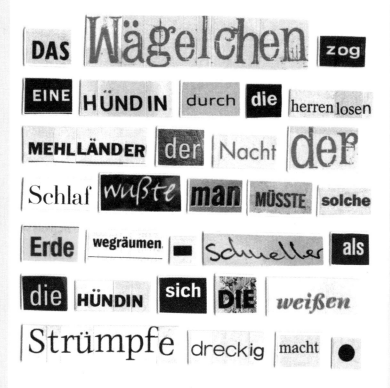

DAS Wägelchen zog
EINE HÜNDIN durch die herrenlosen
MEHLLÄNDER der Nacht der
Schlaf wußte man MÜSSTE solche
Erde wegräumen — schneller als
die HÜNDIN sich DIE weißen
Strümpfe dreckig macht ●

a dog pulled
the little barrow through
the abandoned flourlands
of the night
sleep knew one must
put such lands away
before the dog makes the white
stockings dirty

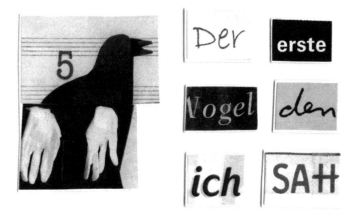

Der erste Vogel den ich SAH

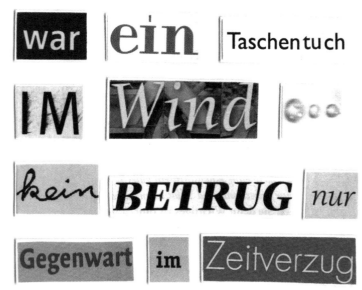

war ein Taschentuch IM Wind ... kein BETRUG nur Gegenwart im Zeitverzug

The first bird
that I saw
was a tissue
in the wind
no sham or play
just the present
with a delay

Hinter den DETAILS sah man der Lüge FREI ins Dekolleté MEHLWEISS ging Sie bis zum großen Zeh

behind the details
one saw the lie
free! in décolletage
and went flour white
up to
the big toe

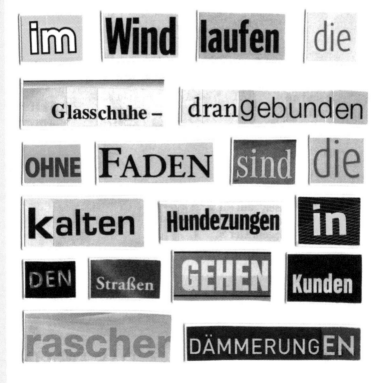

im Wind laufen die

Glasschuhe – drangebunden

OHNE FADEN sind die

kalten Hundezungen in

DEN Straßen GEHEN Kunden

rascher DÄMMERUNGEN

the glass shoes
run in the wind
cold dog tongues
tied on
without thread
in the streets
shoppers stroll
rapid twilights

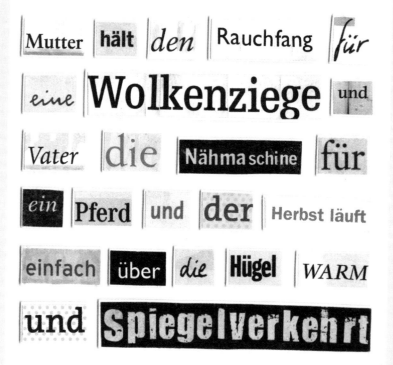

Mutter hält *den* Rauchfang *für* eine **Wolkenziege** und Vater die Nähmaschine für *ein* Pferd und **der** Herbst läuft einfach über *die* **Hügel** *WARM* und **Spiegelverkehrt**

Mother holds the flue for
a cloudgoat and
Father the sewing machine
for a horse and the autumn runs
simply over the hill
a warm mirror image

Der Himmel glich

dem TAUBENKÄFIG

Gott reparierte

EINER Fliege DEN Pelz

einer KIRSCHE den Stein

mich ließ ER sein.

the sky resembled
a birdcage
God repaired
the fly's fleece
the cherry's pit
me
he let be

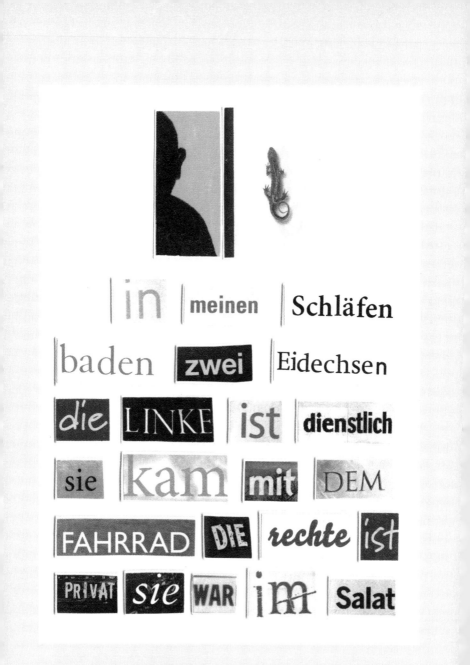

In my temples
two lizards bathe
the one of the left
is on business, came by bike,
the one on the right
is private, was
in my salad

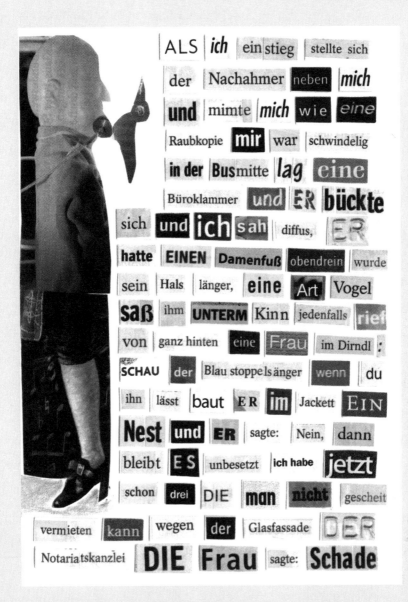

ALS *ich* ein stieg stellte sich der Nachahmer neben *mich* **und** mimte *mich* wie *eine* Raubkopie **mir** war schwindelig **in der** Bus mitte *lag* eine Büroklammer **und ER bückte** sich **und ich** sah diffus, ER **hatte EINEN Damenfuß** obendrein wurde sein Hals länger, *eine* Art Vogel **saß** ihm **UNTERM** Kinn jedenfalls rief von ganz hinten eine Frau im Dirndl : **SCHAU** der Blau stoppels änger wenn du ihn lässt **baut ER im** Jackett EIN **Nest und ER** sagte: Nein, dann bleibt **E S** unbesetzt ich habe **jetzt** schon drei DIE **man nicht** gescheit vermieten kann wegen der Glasfassade DER Notariatskanzlei **DIE Frau** sagte: **Schade**

as I returned from the interrogation
I was no longer anyone's child
and no longer related to me
the furniture of the trees ran
at the kerbside
but where
did the wind
come from

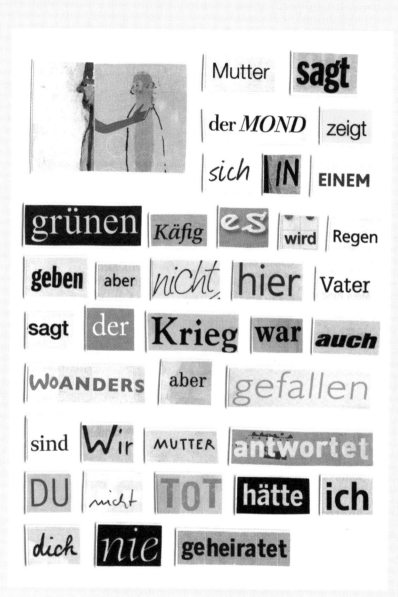

Mother says
the moon
shows itself
in a green cage it will rain
but not here Father
says the war was also
elsewhere but we
were the ones who fell
Mother answers
you not dead if only
I had never married you

Milch ist der ZWILLING von TEER IN Weiß oder SCHWARZ KANN MAN lügen Mutter schiEBT EIN BONBON IM Mund HIN UND her Vater TELEFONIERT mit DEN Fliegen

Milk is tar's twin
in white or black
one can lie
Mother pushes a bonbon
back and forth in her mouth
and Father's on the phone
with the flies.

erst blühen uns
DIE Bäume durch
den Kopf jetzt
wenn Sie kann zieht
die Aprikose IHR gelbes
Heimweh AN DAS ist wie
ES ist UND war wie ES
WIRD hast DU gesehen
DAS SYSTEM der Aprikose
hat sich noch NIE geirrt

first the trees blossom
through our heads
now when it can
the apricot puts
its yellow homesickness on
that's how things are
and were, and
always will be
do you see
the apricot system
has never once malfunctioned

he said
the red
in the red army
you know is
a) blood in grass
and b) blood
in snow

ST. JOHN THE BAPTIST PARISH LIBRARY
2920 NEW HIGHWAY 51
LAPLACE, LOUISIANA 70068

The Word Absolutely is Tired of the Word Absolutely

im Feld IST das Getreide müde vom Getreide und die Sandmücken müd von den Sandmücken die Brennerei von der Brennerei UND DER Wind vom WIND das WORT UNBEDINGT ist MÜD vom Wort UNBEDINGT UND DIE Sonne MUSS durch DEN Rennzirkus, doch hinter dem Busbahnhof im Getreide dreht ein Vogel beide Augen hundeschlecht UND stark geschminkt in steifer Seide

in the field the grain is tired
of the grain and the sandflies
tired of the sandflies and the
distillery of the distillery and
the wind of the wind the word
absolutely is tired of the
word absolutely and the sun must run
through the racing circus
but behind the train
station in the grain
winds a bird
both eyes dog awful and with
lots of makeup in stiff silk

in den Straßen mit den frierenden
alleinregierenden Laternen heiraten
die Birnenbäume zweimal ERST sich
SELBER später IHREN ZUFALL – aber
FRAG mich besser NICHT wie DIE
BLÄTTER fliegen lernen und WAS
er an MIR riecht DASS er
mir nachkommt der magere
Trompetennasenhund

In the streets with the freezing cold
sole governing lanterns the pear trees
marry twice first them
selves later their happenstance — though
better not to ask me how these
leaves learn to fly and what he smells on me
that's making him follow me the lean
trumpet nosed dog

ich hob den Kopf doch
DER Himmel hing LEER
und weißwolkig; mit dem
Magnetsinn der TAUBE
meinte der HERR ich sollte
packen solang ich
NOCH an mir beteiligt bin

I lifted my head but
the sky hung empty
and white cloudy; with the
magnetoception of the pigeon
the man said I should
pack as long as I still
have anything to do
with myself

Maisfelder **singen** länger

ALS DER **WIND** **Wolken**

fliegen kälter **Pfirsiche**

herrschen **gelber** **ALS**

SIE sind (**ich** werd älter)

Fields of corn sing longer
than the wind clouds
fly colder peaches
reign yellower than
they are (I grow older)

BEI Wind sind im Birnenlaub dieselben Flecken- DIE Mutter AN den FEDERN des Perlhuhns UND mich AM Leder des Koffers erschrecken

When the wind blows
in the pear boughs
there are the same
spots that terrify Mother
on the guinea fowl's feathers
and me on the suitcase's
leather

Früher hatte meine MUTTER eine moderne TASCHE aus Fischhaut ich wusste dass sich darin WENN SIE DIE aus der Hand legt sofort etwas bewegt

my mother
use to have
a modern bag
made of fish hide
I knew
that as soon
as she took it in hand
immediately something
moved inside

Who Knows Whose Life I Steal

Weizenfeld IM gelben

HEMD große Mühle

KALTES Mehl oder

Wer weiß wem Ich

DAS Leben STEHL

wheat field in a yellow
shirt big mill
cold meal
or who knows whose
life I steal

die Musikanten spielen in den Bäumen JUNGE Hunde tanzen auf den STÜHLEN sitzt der Wind und der Nachbar stürzt AUS dem Fenster weiß schon ein Jahr nicht mehr was Türen ODER Füße sind

the musicians
play
in the trees young
dogs dance the wind sits
on stools by the bar
and the neighbour falls
out of the window hasn't known
for a year now what
dogs and feet are

Wir hatten Uns BEINE vom WIND GELIEHEN ALS Wir geflohen SIND der Mond STAND dünn war eine Glaspfeife hatte DIE Weite greifbar unter SICH wie warmes Pech Wir sprachen auch DIE nächsten Tage nicht weißt Du wie man Steine BRICHT

we had borrowed
legs from the wind
when we flew
the moon stood thin
was a glass pipe had the expanse
tangible beneath it like
warm misfortune we didn't speak
the next days either
you know how
one breaks stones

Vom Grenzhimmel

sieht MAN NUR die

Unterseite und zwei drei

Untote BIS zum Hals

UND BIS ES knallt

im lauernden Getreide

from the skyline
one sees
only the underside
and two three
undead up to the neck
and until it snaps
in the skulking grain

iM Gelbrockmuster
DES langsam schmal
werden den MONDES IST
das feurige Gespür FÜR
Unbewohntes UND
ES ist nicht VON HIER

in the yellow-skirt design
of the slowly
shrinking moon
is the fiery sense of
uninhabited and
it is not from here

der BOULEVARD arbeitet

mit Beton das Mobiliar

mit HOLZ DIE Gefahr

mit Spinnern im Bonbonladen LEGT

MIR der Inhaber die Karten

IN manche Zonen sei ich nicht

mitgekommen, aber von außen

gesehen, wolle ICH gehen, sagt ER

DAS *gewisse Etwas* habe 7 Zehen,

So Mo Di Mi Do Fr Sa

ROTE Kirschen bleiche Brote

sagt ER setz dich Barbara

the street works
with cement the furniture
with wood danger
with wackos in the candy store
the owner read my cards
I hadn't gone into some of the
zones, but seen from the
outside, I wanted to go, he said
the certain something has seven toes
Sun Mon Tues Weds Thurs Fri Sat
red cherries pale bread
have a seat, Barbara, he said

Der Pförtner SAGT vom Vogel her ist höheres UnKRAUT ein Wald SO WIE der Vogel vom UNKRAUT her eine portable IRRENANSTALT wenn man länger nicht HINSCHAUT, noch mehr

the doorman said
to the bird high weeds
are a forest much the same
the bird to the weeds
is a portable
asylum for the insane
if you no longer look,
even more so

ich nannte
DEN HERING
die TAUBE
mit HALSRING
und Federn im dünnen ÖI
des Regens den GRÜNEN KOFFER
der Bäume ER sagte wir
meinen aber SIE brauchen GAR
keinen deswegen sagte ich SIE
täuschen SICH – immerhin bin ICH
meine unbewohnte Nachbarin

I named
the herring
the doves
with neck rings
and feathers in the thin oil
of the rain the green suitcase
of the trees he said we
deem but you don't seem
to need anyone so said I
you fool yourself — and still I remain
my uninhabited neighbour

Mutter ist *Mutter* **Ihr**
Beruf *bin* ich **VATER** ist
Lkw-Fahrer **WAR** *er* seinen Beruf
fraß *der* **SUFF** Was *ich*
versteh *unser* **HAUS** hängt
pelztief *im* Gras dann
pelztief **IM** *Schnee*
aber **WER** *wechselt* *das*

Mother is Mother I am her
occupation Father is
was a truck driver booze
ate his dues what I
understand our house hangs
pelt deep in the grass then
pelt deep in snow
who changes it though

Wolken zeigen das Zerteilen des Fisches IN Hellblau ES HAT wo man NICHT reden darf GLEICH etwas POLITISCHES

clouds
show fragmentation
in light blue of herring
where speech is forbidden
it immediately has
political bearing

EINS *und* EINS
ist entweder egal
oder im freien Fall
wer **zieht** den Unterschied MIT wilder
Seide unters **Augenlid** UND
DIE Wachstasse **hinter** DIE
Wange wo nimmt *die* lange
Angst SO weiße **Pfoten** HER WER
streut den *Zucker*
UM DAS HAUS UND stopft
Mutters **Lippen** *mit* dem
elternlosen Lächeln AUS

one plus one
is either all the same
or in free fall
who pulls the difference with wild
silk under the eyelid and
the paper cups behind the
jowls where the long fear takes
such white paws who
scatter the sugar
around the house meanwhile
and stuff Mother's lips with the
parentless smile

Angst IST ein GRELLER Stoff der beim TRAGEN auffällt wie ein Hühnerkopf als Brosche am Mantelkragen aber ein Polizist hat mal gesagt wunderbar dir glänzt steigende Furcht im Blick wie Kaviar

fear is
a glaring
stuff that
stands out when carried like
a chicken head
as a brooch
on the coat collar but
a policeman once said
rising fear glistens wonderfully afar
in your eyes like caviar

TIEF zieht MIR der
Schlaf DIE Kappe ins
GESICHT allerdings ist sie aus
Fleisch RECHTS kleines SCHAF
links großer Pfau DIE beiden
schicken mich auf Gräserschau

sleep pulls the cap
deep in my
face certainly it is out of
flesh to the right a small sheep
to the left a big peacock both
send me to a lawn garden show

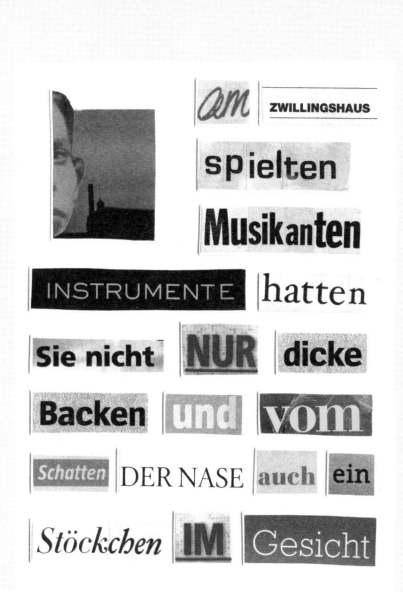

am ZWILLINGSHAUS
spielten
Musikanten
INSTRUMENTE hatten
Sie nicht NUR dicke
Backen und vom
Schatten DER NASE auch ein
Stöckchen IM Gesicht

in the twin
house
musicians were playing
no instruments
in the place
only fat cheeks
and from the
shadow of the nose also
a stick in the face

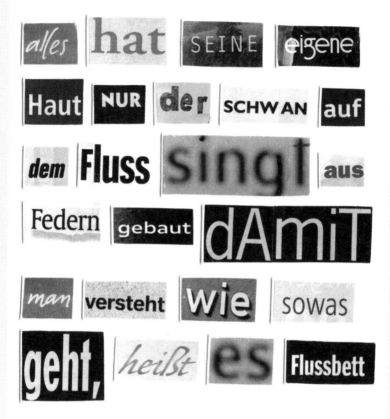

alles hat SEINE eigene Haut NUR der SCHWAN auf dem Fluss singt aus Federn gebaut dAmiT man versteht wie sowas geht, heißt es Flussbett

everything has its own
skin only the swan on
the river sings built
out of feathers so that
one understands what's
at hand it's called riverbed

gestern saß ICH neben dem Spiegelfabrikant sein OHR hob AB WIE ein Rosenblatt, ich wollte ES fangen bevor es verschwand aber er schrie es wird NICHTS nützen BLEIBEN Sie sitzen

yesterday I sat
next to the owner
of the mirror factory his
ear took off like a
rose petal, I wanted
to catch it before it vanished
but he shouted
it's of no use
just remain seated

ALS der Uhrmacher
tot war, KAMEN
Bartdiebe und
kämmten sein HAAR hintereinander
in den Straßen sahen
SIE wie geflügelte Musikanten
AUS und wir gaben IHNEN BROT
SIE aber fraßen eine große
Leere ins Abendrot und
trugen UNSERE her umliegende ZEIT
als bläuliche VOLIERE

when the watchmaker
had died beardthieves came
and combed his hair one after the other
in the streets they looked
like winged musicians
and we gave them bread
but they ate a big
void in the sunset
and carried our dawdling time
like a livid aviary

Womit verdient das NEUE Gras den

KOFFER in GRÜN der NEUE

SCHNEE den KOFFER IN WEISS

ich kann MICH fertig machen

falls es meine sind der Wind

VERDIENT SEIN Hemd IM LACHEN

der NACHTPORTIER hat graue

Möbelfüße oder wär gut

WENN mich die

nachgewiesene Angst

ih RUHE ließe

with what does the new grass earn the
suitcase in green the new
snow the suitcase in white
I can get ready
in case they're mine the wind
earns its shirt in laughter
the night doorman has grey
furniture legs or
would be good
if proven fear
would leave me in peace

einmal baute mein Vater eine FLATTER OB SIE AUS DEM alten Hemd oder aufgeschlitzten Papiersack war weiß ICH nicht DER WARME Wind trieb UNS den halben TAG DIE Haare ins Gesicht

once my father
built a flutter
whether
it was out of
the old shirt or
the paper bag
ripped open
I can't say
the warm wind
blew our hair in our faces
half the day

Was als **Späher** *im* knielangen Mantel,

mit GRAUEM Herrenhut **hinter**

den HÄUSERN geht durch **den**

erfrorenen Klee *ist* eine

kleine **unbemannte** TANNE

DIE **NACHT** baut Schnee

what walks like a scout
behind the houses in a
grey hat and knee-length coat
through the frozen clover is a
small unmanned fir tree
the night builds snow

als der Abriss des Mondes anfing wurde EIN KÖNIG BESEITIGT und einer nicht weil ES nicht ging und der Mond HING MAL voll wie die kugel mal dünn Wie die SCHLANGE weil es noch lange nicht ging

when the
demolition of the
moon
began a king
was removed and one not
because it wasn't working and
the moon hung now full
like a bullet now thin
like a line because
it still didn't work
for a long time

Der mit den blauen SCHLÄFEN
sagt WENN ICH das GLÜCK
RICHTIG versteh ENTKOMMT
von vier HASEN der FÜNFTE
in der Haut DES sechsten
durch den Seidenklee

the man with the blue temples
says when I have properly
understood happiness
the fifth of four rabbits
will escape in the
skin of the sixth
through the silkclover

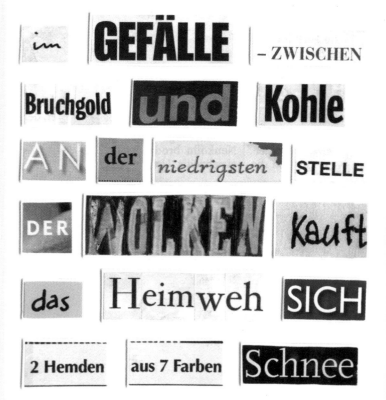

im **GEFÄLLE** – ZWISCHEN

Bruchgold **und** **Kohle**

AN der *niedrigsten* STELLE

DER WOLKEN *kauft*

das Heimweh SICH

2 Hemden aus 7 Farben Schnee

on the slope between
scrap gold and coal
at the lowest spot
of the clouds
homesickness buys itself
2 shirts of 7 colours of snow

Die Räder waren zu viert und
alle Türen nummeriert ICH saß
in der Schläfe der Nachbarin auf
dem Stuhl aus GLAS bevor
der WAGEN FUHR sagte
der WÄCHTER DURCH den ALTEN
LAUTSPRECHER er empfehle gute
FAHRT und MAUL halten
und Kofferraum öffnen

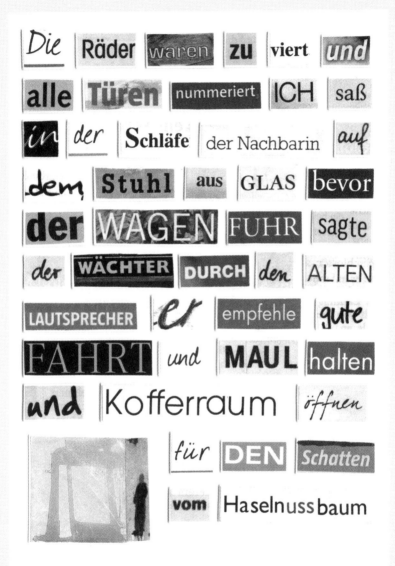

für DEN Schatten
vom Haselnussbaum

the wheels were in fours and
all numbered doors
I sat
in the neighbour's temples on
the chair
out of glass
before the car departed
the watchman said through the old
loudspeaker advised
have a nice trip
and shut your trap
and open the trunk
for the shade
of the hazelnut tree

Die streunenden Hunde
verlieren den Kopf vom
wackligen Brennen der Sterne
am TAG ist DER HIMMEL
ein BLAUER Zylinder nachts
eine durchschossene KASERNE

the stray dogs
lose their heads
because of the wobbly burning
of stars
the sky by day is a blue
top hat by night
army barracks
shot through

das DORF

ist *weit*

und **Mutter**

schreibt

DER SOHN *vom* Nachbar *stirbt*

die SONNE wird wie **KALTE**

MILCH die Birnbäume von nebenan

machen *ihre* **Holzarbeit**

the village
is far
and Mother
writes
the son from next door
has died
the sun is cold milk the
pear trees next door
do their woodwork

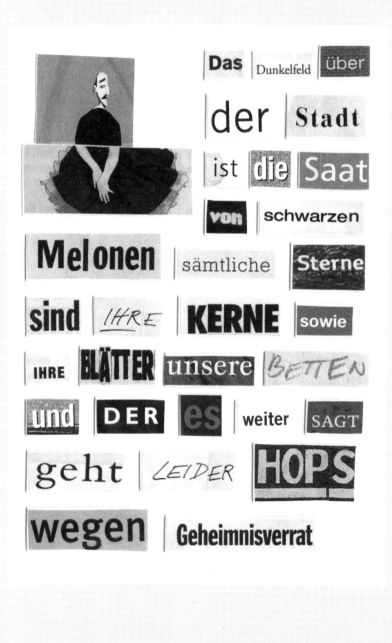

Das Dunkelfeld über der Stadt ist die Saat von schwarzen Melonen sämtliche Sterne sind IHRE KERNE sowie IHRE BLÄTTER unsere BETTEN und DER es weiter SAGT geht LEIDER HOPS wegen Geheimnisverrat

The dark field
over the city
is the seed
from black
melons all the stars
are their core like
their leaves our beds
and anyone
who passes it on
alas goes whoops
because
betrayal of state secrets

dass Gefühle Röcke aus 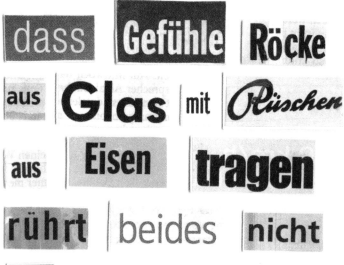 Glas mit Rüschen aus Eisen tragen rührt beides nicht AN | Grundsatzfragen.

greiffähige
Hand

that feelings wear
skirts out of glass
with frills
out of iron
stirs neither
on questions of principle

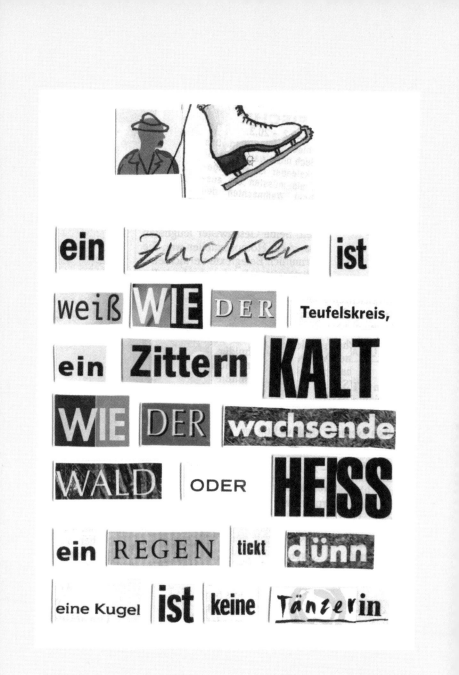

ein *Zucker* ist
weiß WIE DER Teufelskreis,
ein Zittern KALT
WIE DER wachsende
WALD ODER HEISS
ein REGEN tickt dünn
eine Kugel ist keine *Tänzerin*

sugar is white
like a vicious circle
a quiver is cold
like the growing
forest or hot
rain ticks thin
a bullet is no dancer

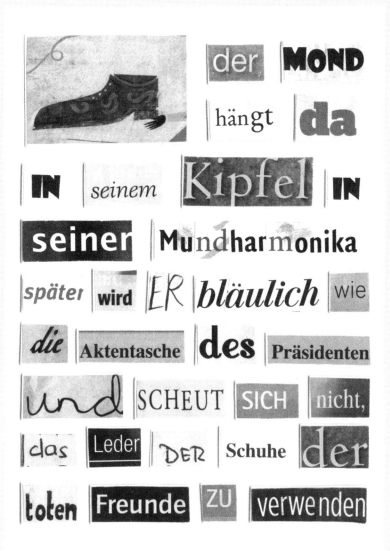

der MOND hängt da IN seinem Kipfel IN seiner Mundharmonika später wird ER bläulich wie die Aktentasche des Präsidenten und SCHEUT SICH nicht, das Leder DER Schuhe der toten Freunde ZU verwenden

the moon
hangs there
in its crescent in
its harmonica
later it will be
blueish like the president's
briefcase
and is not shy
to use
leather
from the shoes
of dead friends

Ich hab im Schlaf ein HAUS MIT schmaler TÜR (und DEM Portier AUF seinem STUHL) EINEN Koffer und EIN SCHAF gesehen, das SCHAF konnte mit der TÜR (UND DEM Portier auf seinem STUHL) am Hals durch den Koffer über die Dächer gehen es wird kein Traum gewesen sein um 6 Uhr früh sah ich den PORTIER neben der TÜR mit einem Koffer STEHEN

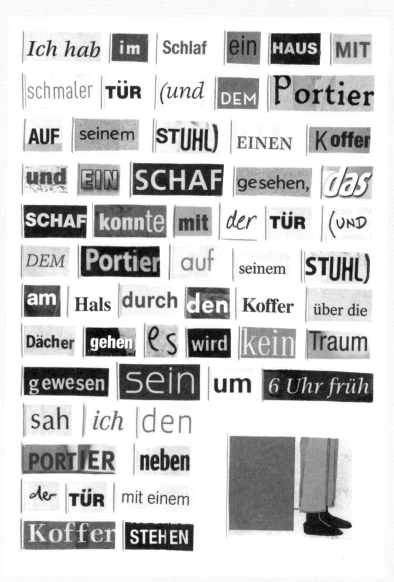

while asleep I saw
a house with a small door
(and a concierge on his stool)
a suitcase and a sheep
the sheep could walk
with the door (and the concierge
on his stool) on its neck through the
suitcase over the roofs
it cannot have been a dream
at 6 in the morning
I saw the concierge
standing with a suitcase
next to the door

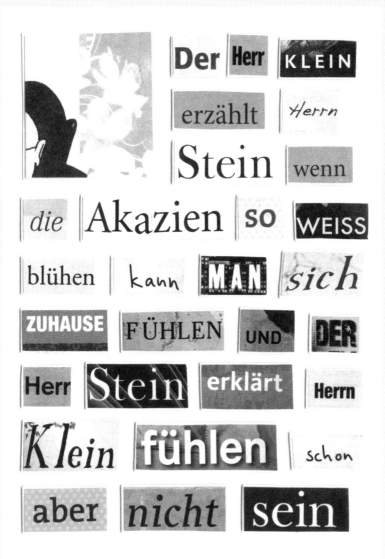

Der Herr KLEIN erzählt Herrn Stein wenn die Akazien so WEISS blühen kann MAN sich ZUHAUSE FÜHLEN UND DER Herr Stein erklärt Herrn Klein fühlen schon aber nicht sein

Mr Klein
told Mr
Stein when
the acacias so white
are in bloom
you can
feel at home
you see
and Mr Stein
explained
to Mr Klein feel
but not be

im Niedergang HAT der SOMMER
MIT DEN GRÜNEN Krallen
uns dem schneidigen Gesang der
Parallelwelt im steil aufgestellten
nierengelben Maisfeld
überlassen. AN den Details vorbei
wird man sich anpassen

waning summer
with the green claws
left us to the spirited song of the
parallel world in the steep
kidney yellow corn field.
One will adapt
retrospectively
to the details

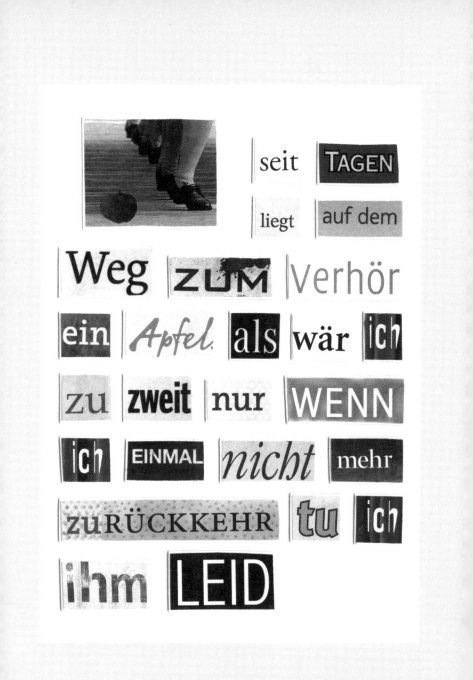

seit TAGEN
liegt auf dem
Weg zum Verhör
ein Apfel. als wär ich
zu zweit nur WENN
ich EINMAL nicht mehr
zuRÜCKKEHR tu ich
ihm LEID

for days
on the way
to the interrogation
an apple has lain
as if I were a pair
but when someday
I don't return
I cause him pain

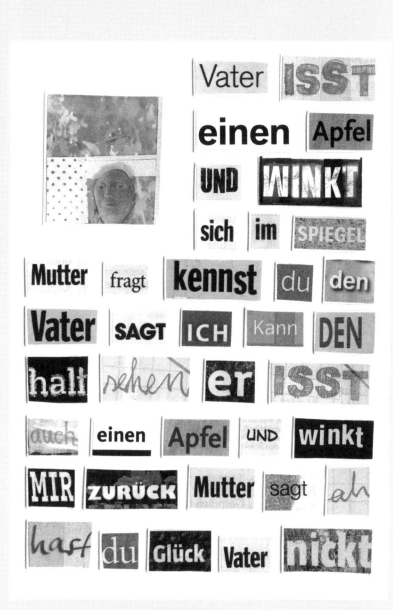

Vater ISST einen Apfel UND WINKT sich im SPIEGEL Mutter fragt kennst du den Vater SAGT ICH Kann DEN halt sehen er ISST auch einen Apfel UND winkt MIR ZURÜCK Mutter sagt ah hast du Glück Vater nickt

Father eats
an apple
and winks
in the mirror
Mother asks do you know him
Father says I can see him
also eating an apple and winking
back at me Mother says ah
you are lucky Father nods

The Skin is Just a Splotch of Insulted Batiste

nur ein weißer Porzellankopf sprach nur was ihn

betraf er sei der Inhaber ABER ICH

fragte, warum zünden Sie die Kerzen

AN ich habe nichts getan in den Flammen

sprangen ein Sichelhahn SCHARLACHROT Fische

RAUCHSCHWARZ wie Eisenerz Insekten bleich

wie ROSENQUARZ ich dachte AN die

stramme Rose im Herzen AN die nutzlose SEELE

WIE EIN Sieb der Inhaber fragte aber

WER gewinnt die Oberhand ich sagte

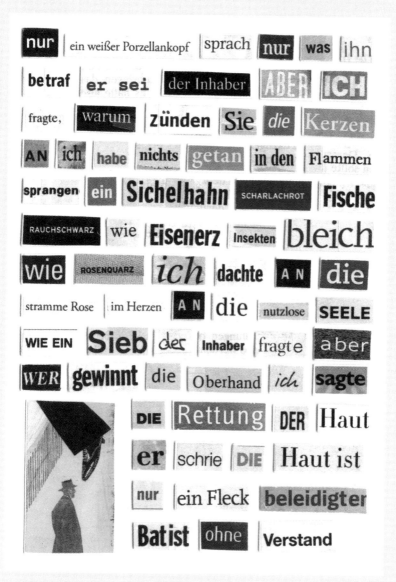

DIE Rettung DER Haut

er schrie DIE Haut ist

nur ein Fleck beleidigter

Bat ist ohne Verstand

just a white porcelain head spoke just what concerned
him he was the keeper but I asked
why are you lighting the candles
I have done nothing
in the flames
jumped a sickle rooster scarlet fish
smoke black like iron ore insects pale
like rose quartz
I thought of the
sturdy rose in the heart
and the useless soul
like a sieve
the keeper asked
but who gains the upper hand
I said saving the skin
he shouted the skin is
just a splotch
of insulted batiste
without any grasp

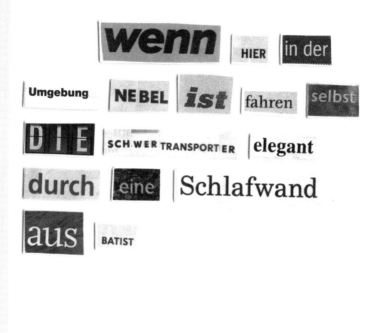

wenn HIER in der Umgebung NEBEL ist fahren selbst DIE SCHWERTRANSPORTER elegant durch eine Schlafwand aus BATIST

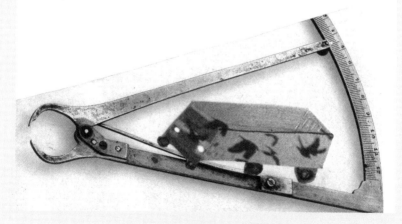

when there's mist
here in the area
even the heavy loads
drive elegantly
through a sleep wall
of batiste